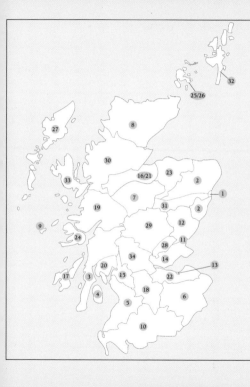

1. Aber[...]
2. Aber[...]
3. Argyl[...] [...]ute
4. The [...]
5. Arran & Ayrshire
6. The Borders
7. The Cairngorms
8. Caithness & Sutherland
9. Coll & Tiree
10. Dumfries & Galloway
11. Dundee
12. Dundee & Angus
13. Edinburgh
14. Fife, Kinross & Clackmannan
15. Glasgow
16. Inverness
17. Islay, Jura, Colonsay & Oronsay

23. Moray-Speyside
24. Mull & Iona
25. Orkney
26. Orkney in Wartime
27. The Outer Hebrides
28. The City of Perth
29. Highland Perthshire
30. Ross & Cromarty
31. Royal Deeside
32. Shetland
33. The Isle of Skye
34. Stirling & The Trossachs

The remaining six books, *Caledonia*, *Distinguished Distilleries*, *Sacred Scotland*, *Scotland's Mountains*, *Scotland's Wildlife* and *The West Highland Way* feature locations in various parts of the country, so are not included in the map list above.

PICTURING SCOTLAND

DUNDEE

COLIN NUTT
Author and photographer

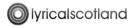

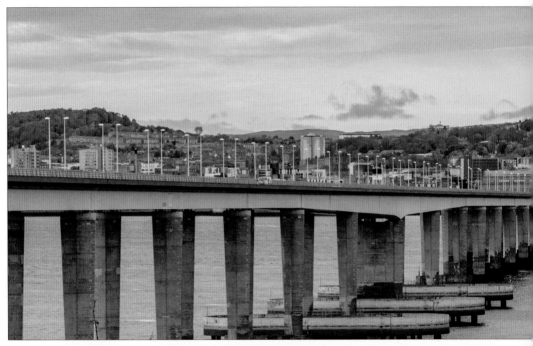

2 A panoramic view of Dundee taken from Fife across the Firth of Tay, with the Tay Road Bridge on the left. The Dundee waterfront is undergoing major redevelopment with new hotels, layout and landscaping.

DUNDEE

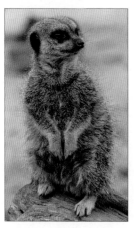

Welcome to Dundee!

Dundee, Scotland's fourth city, stands on the north bank of the Firth of Tay. It has gone through many phases of prosperity and poverty through the years, but now a great resurgence is happening in Dundee – a £1billion waterfront transformation, an ambitious 30-year project that is propelling Dundee towards a sustainable future of innovation and progress, the heart of it being V&A Dundee.

Although it is the country's smallest Unitary Authority, it is second only to Glasgow in terms of population density. The city's beginnings go back to the 11th century. King William's charter in 1191 granted rights to the town such as the right to establish local government and operate a court. Charters also paved the way for greater commerce and by the 13th century Dundee held an annual fair – in those days more of a market than an entertainment. Harbour development stimulated trade and by the 14th century Dundee was one of Scotland's largest towns. The following three centuries saw a pattern of growth and setbacks, of prosperity gained then lost to epidemics, wars with England and, perhaps most destructively, the Civil War. Dundee suffered from both sides; in 1644 the Royalist Marquis of Montrose besieged it and in 1651 Cromwell's forces captured it. Their pillaging cost the lives of up to 2,000 of a population of 12,000. It took Dundee a century to recover.

In the 19th century it was, perhaps, most famous for 'Jam, Jute and Journalism'. Jams date from 1797 when James Keiller & Son established a preserves factory. Jute began to be imported

4

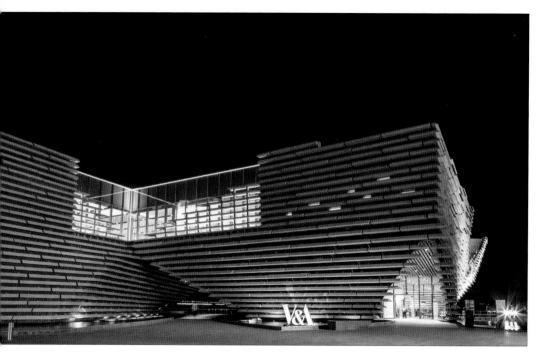

The V&A Dundee. Curving concrete walls hold 2,500 pre-cast rough stone panels weighing up to 3,000kg each, to create the appearance of a Scottish cliff face.

in 1835. Journalism owes much to the success of DC Thomson, creator of comics such as 'The Beano', 'The Dandy' and its character 'Desperate Dan' (see p.35). Sadly, Jam and Jute are no longer going concerns although the history behind them remains. Happily, DC Thomson is still going strong, now housed in a new building. Whaling was also an important part of Dundee's economy and by 1859 the Dundee fleet had its first custom-built whaler. Shipbuilding developed, with Scott of the Antarctic's vessel *Discovery* its most famous achievement. *Discovery* returned to Dundee in 1986 and is one of the city's principal tourist attractions.

But now the vision for a re-developed waterfront has turned into reality – exciting times for Dundee! The whole city-centre waterfront is being re-imagined and redeveloped, the jewel in the crown being the V&A Dundee, opened in September 2018, the first ever dedicated design museum in Scotland and the only other V&A museum anywhere in the world

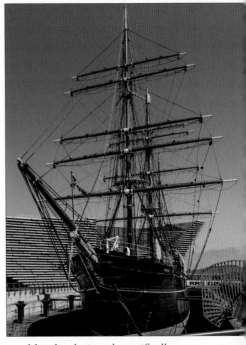

6 RRS *Discovery*, launched in 1901, the first ship in the world to be designed specifically for scientific research.

outside London. V&A Dundee provides a place of inspiration, discovery and learning through its mission to enrich lives through design. Designed by renowned award-winning Japanese architects Kengo Kuma & Associates, this is Kuma's first building in the UK. Kuma's vision is that it will be a welcoming space for everyone to visit, enjoy and socialise in – a 'living room for the city' – and a way of reconnecting the city to its historic River Tay waterfront.

The V&A's total floor area is 8,000m2, of which 1,650m2 are gallery space. Some of this will comprise permanent displays, while other galleries will be used for themed exhibitions for set periods of time, in order to ensure it remains a dynamic experience that attracts people into becoming regular visitors. The first themed exhibition was *Ocean Liners: Speed and Style*. Although it will have closed by the time this book is published, we have included some images from it as a record of the V&A's opening period and because of the mesmerising impression of this era that the exhibits created (see pages 13-15).

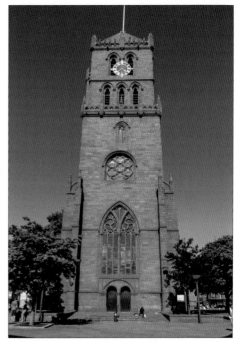

The tower of what used to be known as Steeple Church, Nethergate, is now owned by Dundee City Council. The building is still home to two congregations – see also p.31.

8 Central Dundee viewed from City Square. On the left, Reform Street runs down to The McManus Art
 Gallery & Museum. High Street runs from left to right. The city centre of today still owes much to

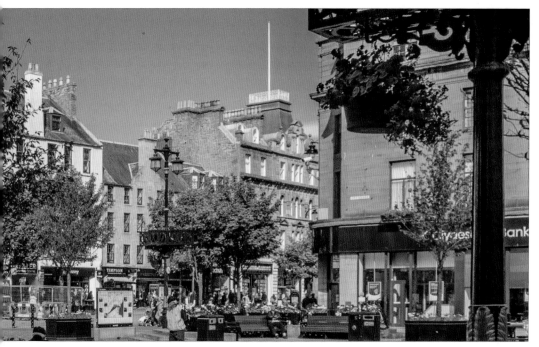

the City Improvement Act of 1871 which swept away many run-down buildings from earlier times.

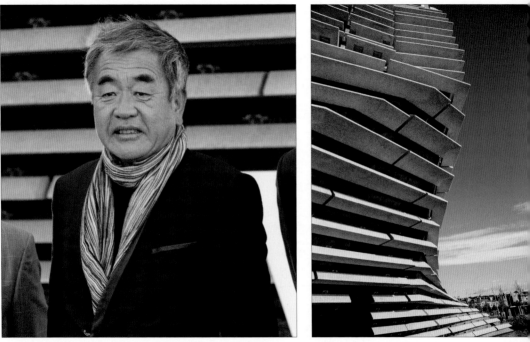

10 Left: the V&A's architect, Kengo Kuma, outside the building at the time of its opening. Right: an angle on the V&A that does resemble the outline of an eroded sea cliff.

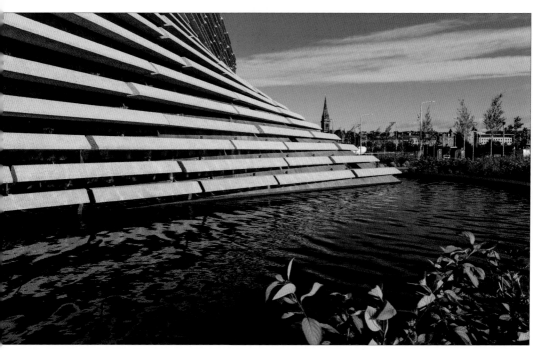

The sea-cliff imagery is sustained by having the building mostly surrounded by water. The spire of 11 St Paul's Cathedral (see pp.44/45) appears to be sitting on a shelf of the cliff!

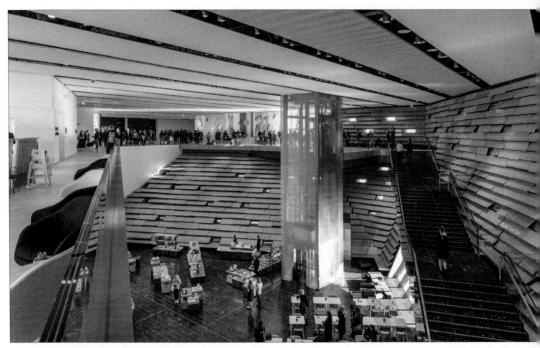

12 The central atrium area of the interior of the V&A. The galleries are on the upper level.

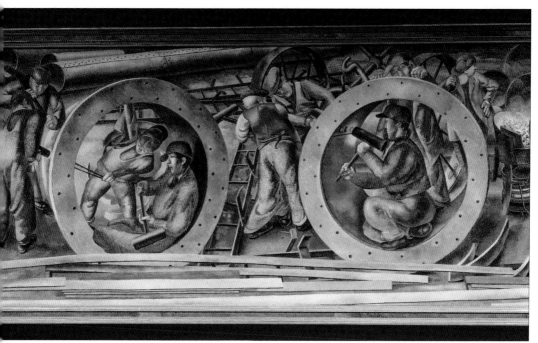

This is a small section of a much larger painting by artist Stanley Spencer called *Shipbuilding on the Clyde*.
It depicts the highly skilled job of the riveters and was commissioned by the government in WW2.

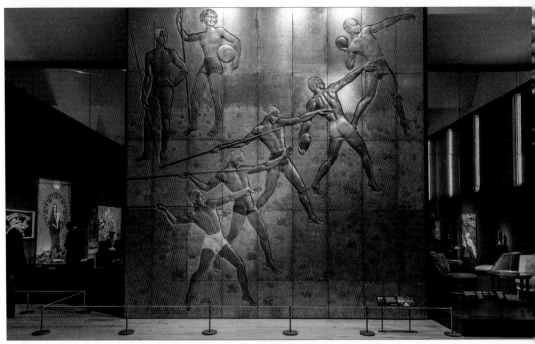

14 This is a panel from the first-class smoking room on the French liner *Normandie*, named *Les Sports*. The golden lacquer panels were made by French lacquer artist Jean Dunand.

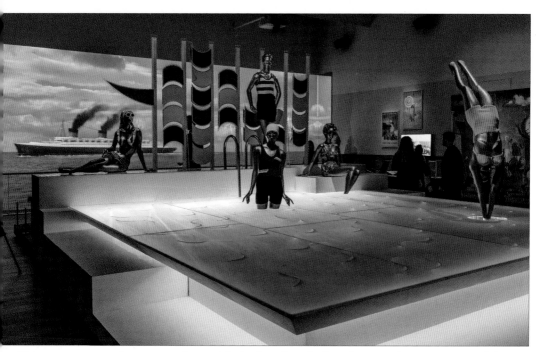

This scene stunningly recreates the pool decks found on the best liners in the Art-Deco era of the 1920s-1930s. The panel at the back is actually a film screen, on which *The Queen Elizabeth* sails by.

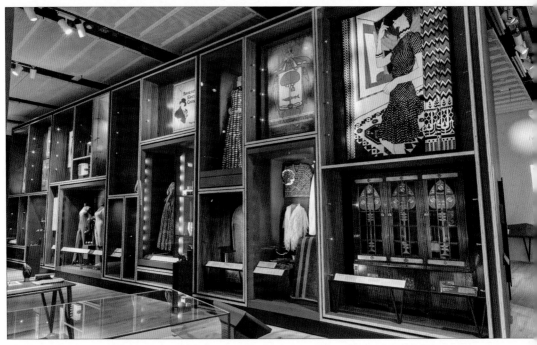

16 Now in part of the permanent exhibits area, a display largely of fabric designs. But in the bottom right cabinet is a rather lovely bookcase . . .

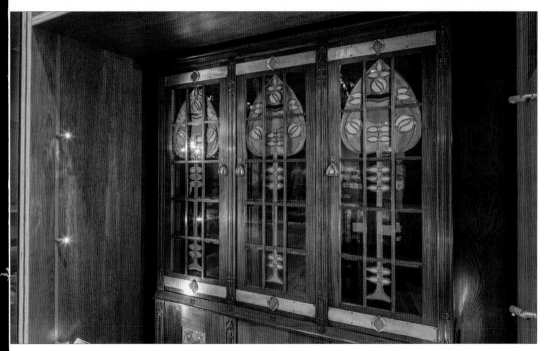

. . . now seen in more detail. It is decorated with the Glasgow rose, a popular motif of the Glasgow style. Designed by George Logan and made in 1901 for the Glasgow International Exhibition.

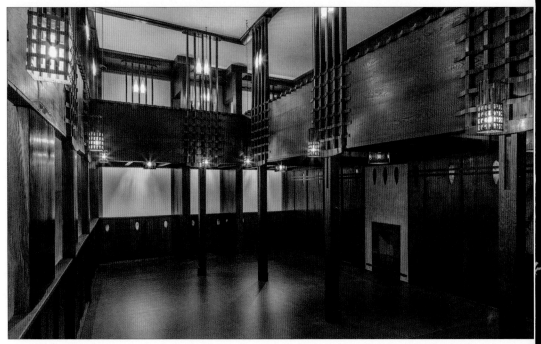

18 Another permanent exhibit is Charles Rennie Mackintosh's wonderful Oak Room, designed in 1907 for a Glasgow tearoom. It has been painstakingly conserved and re-assembled at the V&A.

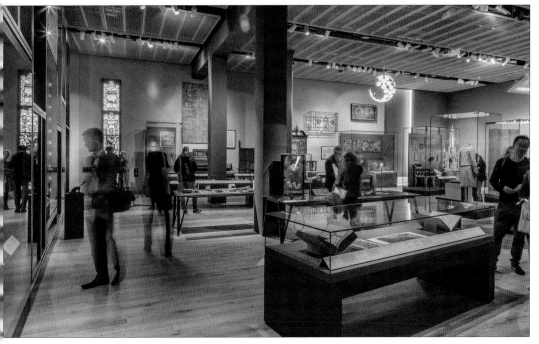

Complete with ghostly-looking visitors, this gallery contains an eclectic mix of artefacts from a stained-glass window (left) to a variety of furnishings and decorative pieces.

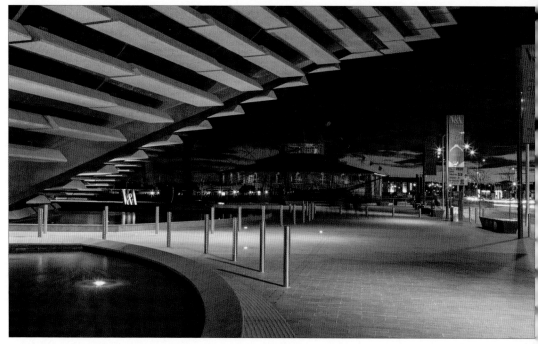

20 Taken from one of the overhanging sections of the V&A, attention now turns to Discovery Point, another of Dundee's iconic attractions, identified by the red lighting around its windows and

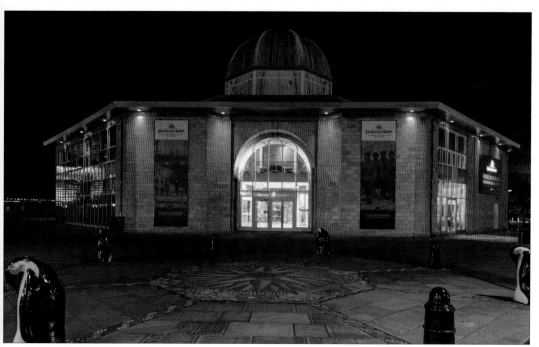

seen in close up here. It tells and re-creates the story of RRS *Discovery*, the first vessel built specifically for scientific research voyages. The penguin statues in the foreground hint that . . .

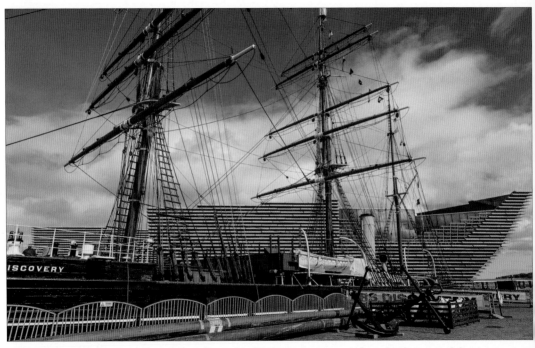

22 . . . the Antarctic figured prominently in the ship's explorations, taking both Scott of the Antarctic and a young Ernest Shackleton to these parts. Today she makes an interesting contrast to the V&A.

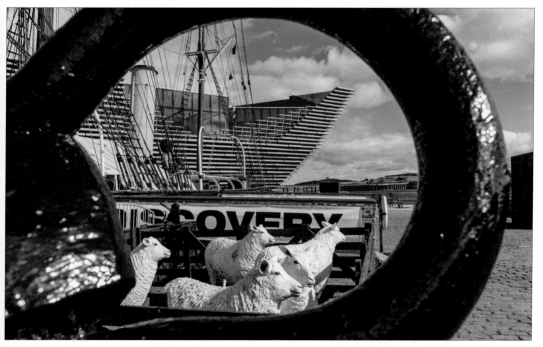

Viewed through the anchor loop, preparations for Scott's voyage include a small flock of sheep, **23** which will become a source of fresh meat when they reach Antarctica.

24 Looking west from Discovery Point: a spectacular sunset (see pages 28-29) is followed by an extraordinary lightshow of under-lit clouds – an afterglow to remember – and record in this picture!

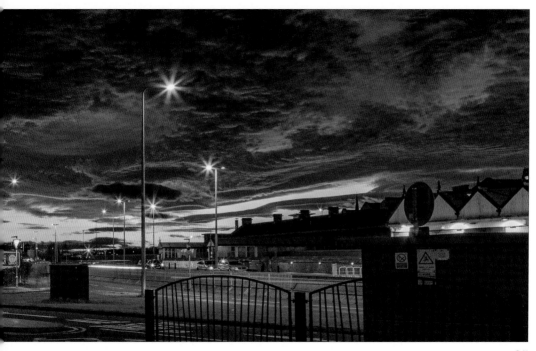

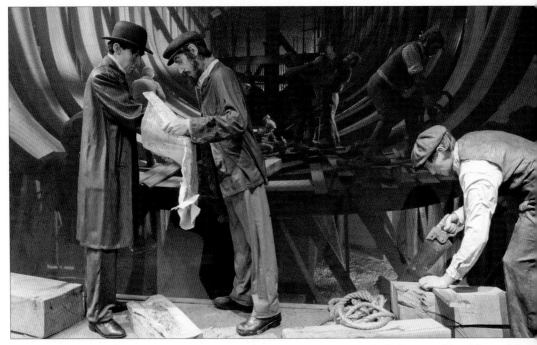

26 Discovery Point is an all-weather, award-winning, 5-star attraction which features this tableau of the construction of *Discovery* and, of course, the chance to explore the ship itself.

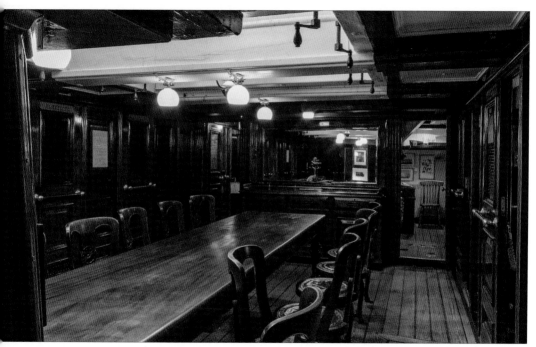

Visitors can board *Discovery* and explore below decks. This is the Wardroom, the mess cabin for the ship's officers. *Discovery* is 52m/172ft loang and 10m/33ft across the beam.

28 The fluke combination of phenomenal sunset light on two banks of cloud and the 'prow' of the V&A give the impression that the building is firing some kind of 'ray' from its top corner.

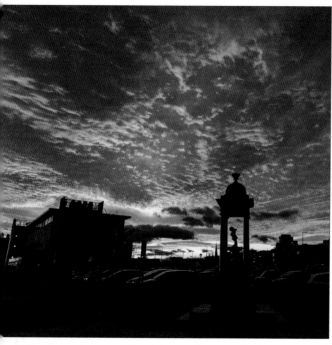

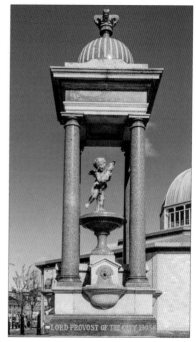

LORD PROVOST OF THE CITY 1905

Left: a few minutes earlier this was the scene in the opposite direction, silhouetting the Alexandra **29** fountain erected in memory of Queen Alexandra, which is seen in more detail on the right.

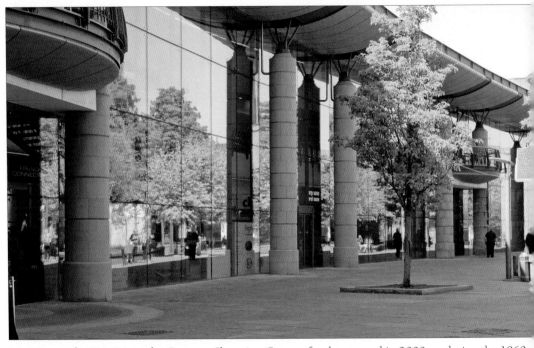

30 Now to the city centre: the Overgate Shopping Centre of today opened in 2000, replacing the 1960s original. The name 'Overgate' comes from the street that used to run where the shops now stand.

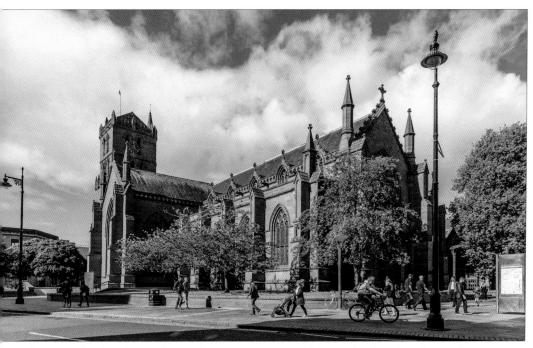

The City Churches (above) house the congregations of The Steeple Church and a youth project (in the centre section) and St Mary's Church in the near (east) end of the building.

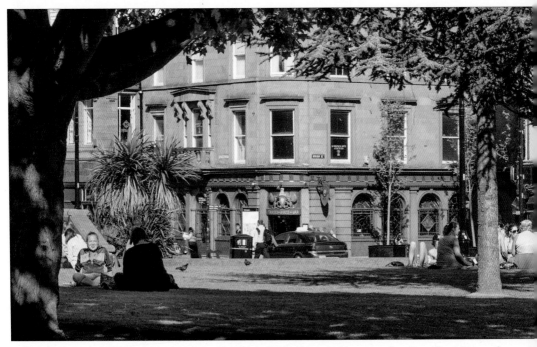

32 Dundonians enjoy a summer day in the pleasant green space between the City Churches and Nethergate. Through the trees is the Trades House Bar at the corner of Nethergate and Union Street

The pedestrianised north-east end of Dundee's High Street, with the former Clydesdale Bank **33** building standing at the point where streets divide into Seagate and Murraygate.

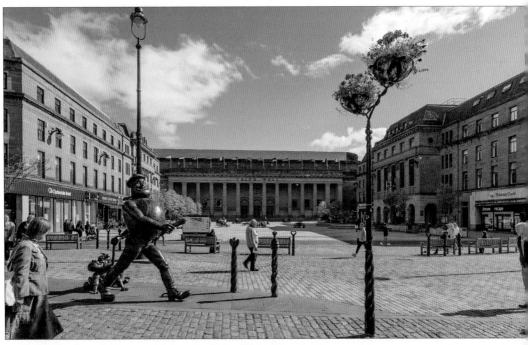

34 Dundee's City Square, a fine piazza where Desperate Dan likes to pose in a position that makes it look as though a lamp post is growing out of his head! This larger-than-life hero of the Dandy comic

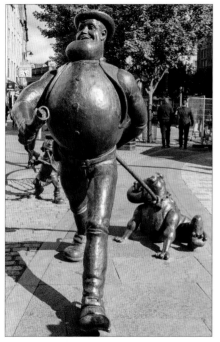

has stood here since 2001, with 'Dawg' in tow and Minnie the Minx (top right) not far behind.
Right, below: one of the beautiful low-relief sculptures that adorn the fountains in City Square.

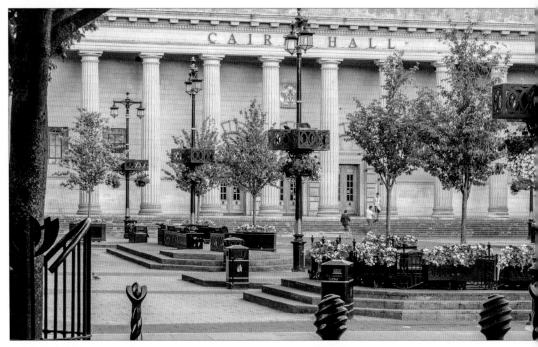

36 Caird Hall in City Square is Dundee's principal concert hall. Although the foundation stone was laid in 1914, due to the First World War it did not open until 1923. It is named after Sir James Caird.

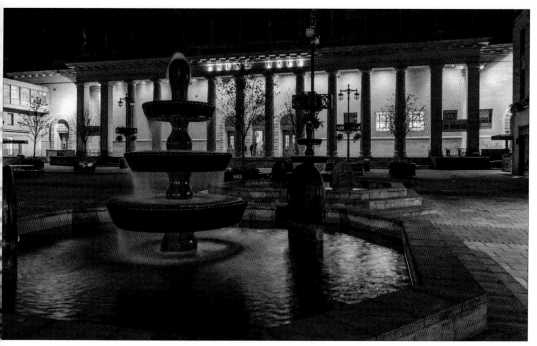

Caird Hall at night, a scene much enhanced by the cycle of different coloured lighting on its frontage and the ornate fountains in the foreground.

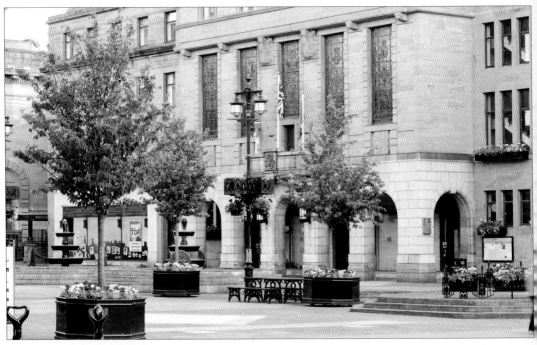

38 Dundee City Hall. In 1914, Sir James Caird, who had made a fortune through the jute trade in the city, pledged £100,000 for the building of a new City Hall and Council Chamber.

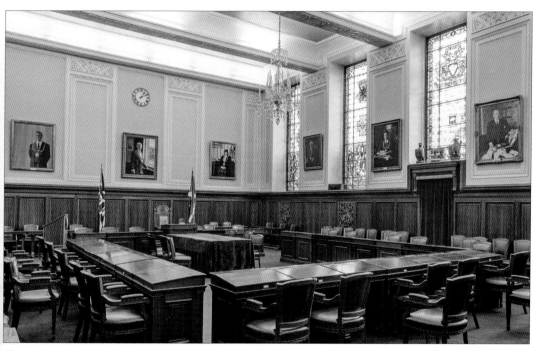

This project was not completed until 1933 and caused the demolition of various buildings including **39** the architecturally significant Town House of 1732. Pictured here is the Council Chamber.

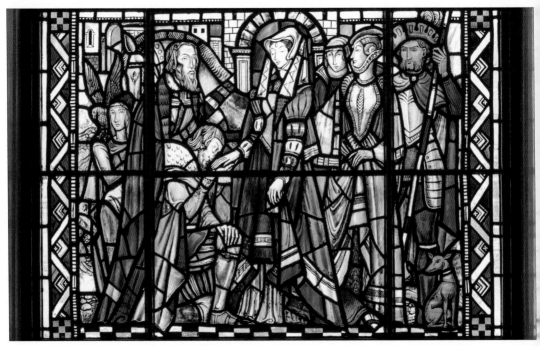

40 Also in the Council Chamber is this splendid stained-glass window depicting Mary, Queen of Scots, visit to Dundee in 1561.

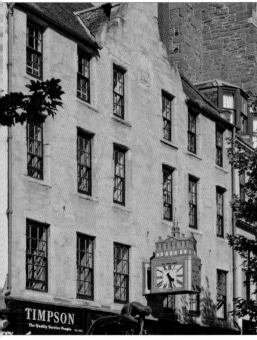
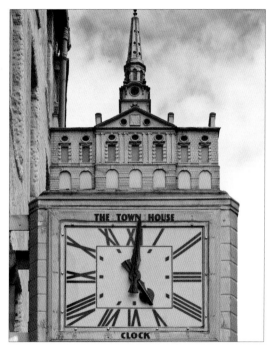

Left: this High Street building has amazingly survived since 1560. Right: the clock dates from 1932 **41**
and carries a model of the old Town House that once stood nearby (see p.47).

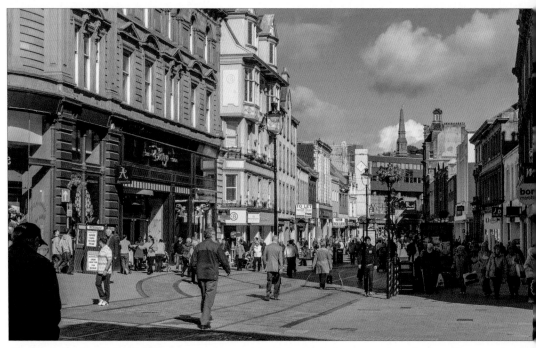

42 More city bustle in Murraygate, where a section of the city's former tram tracks have been retained – a reminder of times gone by.

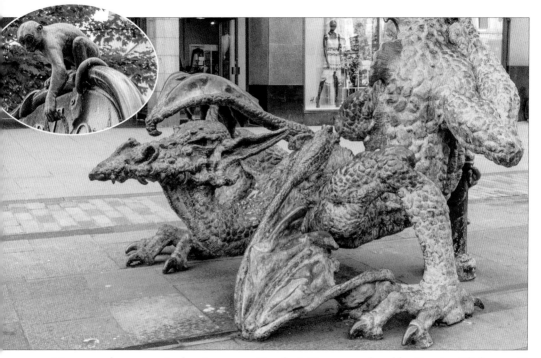

Unexpected creatures in the city centre: Dundee's Dragon, sculpted by Prentice Oliphant, **43** lurks in Murraygate. Inset: mischievous monkey tampers with an Information Board.

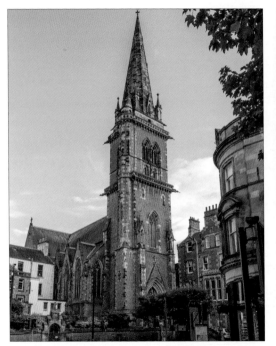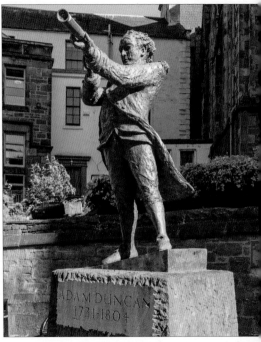

44 Left: the spire of St Paul's, High Street. Right: statue of Admiral Lord Viscount Duncan of Camperdown outside St Paul's. He famously defeated the Dutch fleet off Camperdown in October 1797.

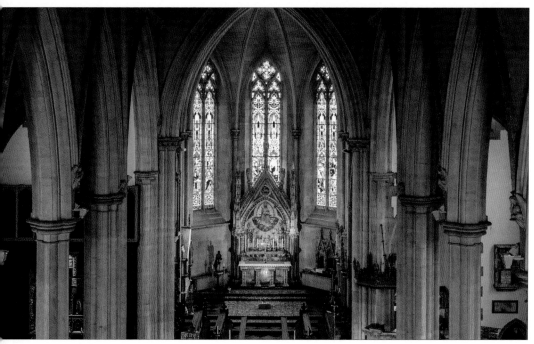

The impressive interior of St Paul's Episcopal Cathedral. Designed by Sir George Gilbert Scott and **45** completed in 1855, since 1905 it has been the Cathedral Church of the Diocese of Brechin.

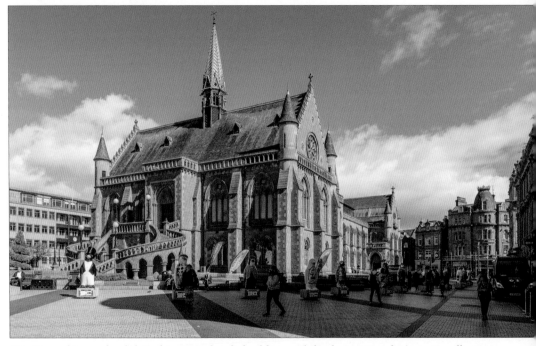

46 Housed in a splendid Gothic Revival-style building and displaying Dundee's main collection,
The McManus Art Gallery & Museum has been at the heart of art and culture in the city since 1867

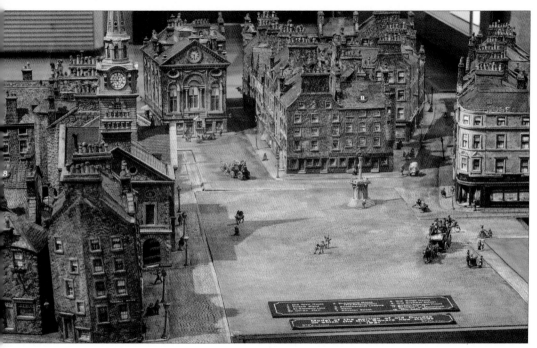

Amongst its many fine exhibits is this model of the centre of Dundee c. 1850. The large building on 47 the left is the 1732-built Town House that succumbed to the 1930s City Square redevelopment.

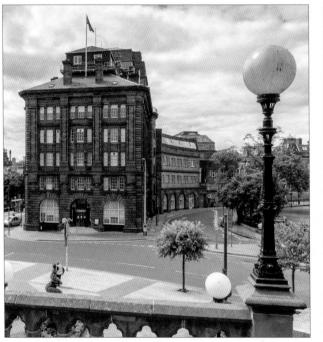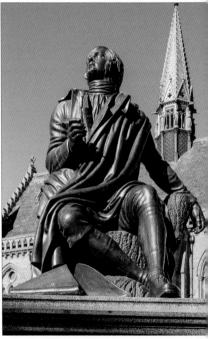

48 Opposite The McManus, the former DC Thomson building is still affectionately regarded as the spiritual home of the Beano, Dandy, The Scots Magazine, The People's Friend and more.

Opposite, right: statue of Robert Burns outside The McManus Art Gallery & Museum; **49**
above: Dundee's new railway station is part of the waterfront redevelopment.

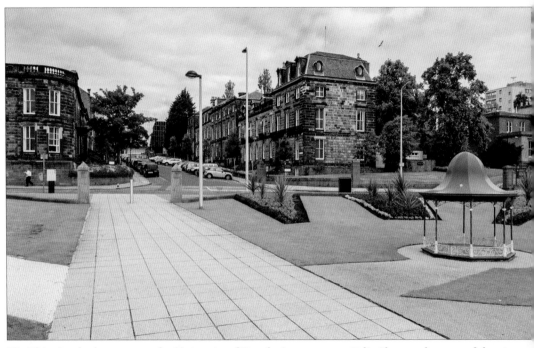

50 This view looks across to the University of Dundee's campus at Airlie Place to the west of the city centre. The small-scale bandstand is a replica of the full-size one at Magdalen Green (see p.63).

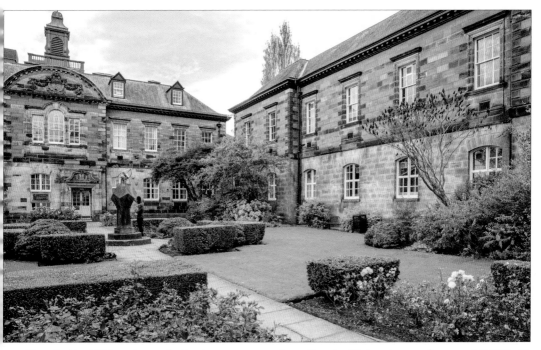

Founded in 1881 and open for business two years later, Dundee University now has over 15,000 **51** students. These are two of its earlier structures, the Carnegie Building, left, and Harris Building, right.

52 The view from the end of Peters Lane shows a variety of university architecture, with the tower of the Harris Building on the left and the modern Library & Learning Centre on the right.

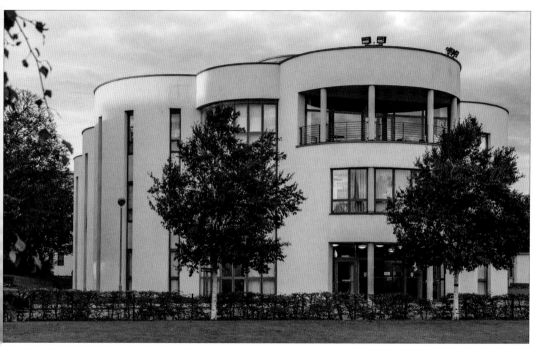

Elsewhere on the campus, the Queen Mother Building, opened in 2006 by HRH Princess Anne, **53** shows off its graceful curves as it catches late-evening sun on its west elevation.

54 While on the theme of education, Dundee and Angus College offers a very wide range of courses from accounting to welding. This is its Gardyne Campus in Dundee.

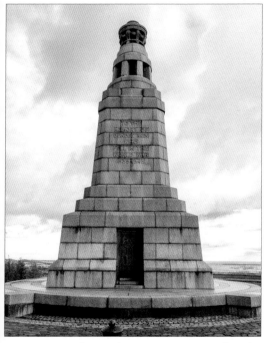
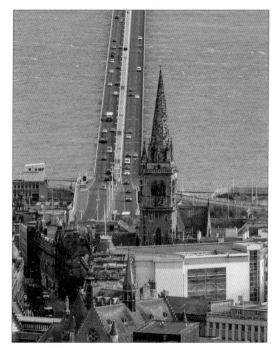

Left: Dundee Law War Memorial. Right: from Dundee Law, St Paul's Cathedral spire points
heavenwards, while the traffic on the Tay Road Bridge gives the impression that you can get there by car!

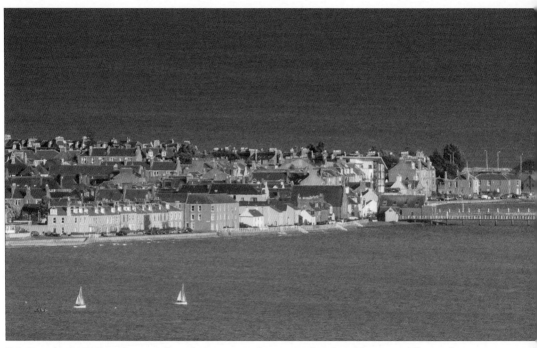

56 Dundee Law provides grandstand views over the city and surrounding area. This is the scene to the east, looking across to Broughty Ferry, with Broughty Castle in its strategic coastal location

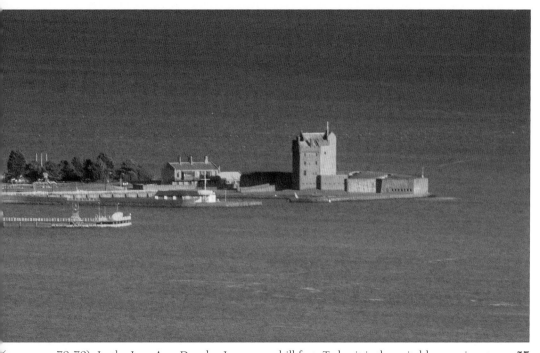

(see pages 78-79). In the Iron Age, Dundee Law was a hill fort. Today it is the suitably prominent location for the city's main War Memorial, erected in 1923.

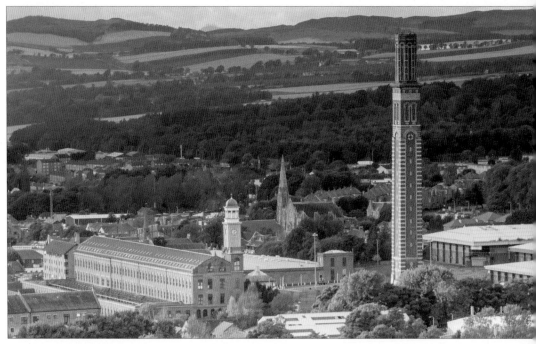

58 Also viewed from Dundee Law, the former Camperdown Jute Mill (now flats) and 'Cox's Stack', its spectacular 86m/283ft chimney, built from coloured bricks in the style of an Italian campanile.

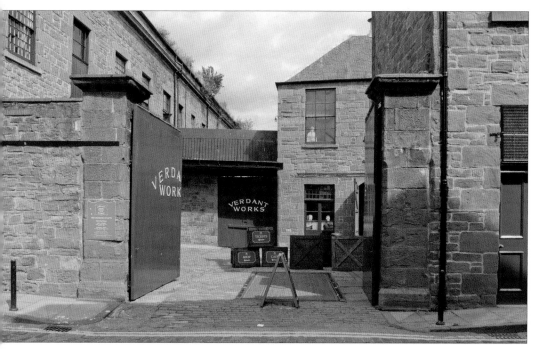

Verdant Works, West Henderson Wynd, is Scotland's Jute Museum. It weaves the tale of jute with the life and work of old Dundee, from the incredible rise of the industry to its subsequent decline.

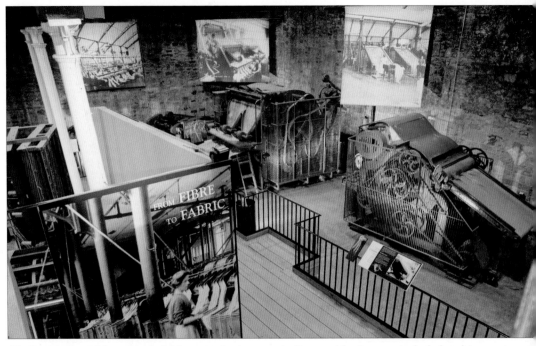

60 During the 19th and early 20th centuries jute was indispensable. Its uses included sacking, ropes, boot linings, aprons, carpets, tents, roofing felt and much more. Pictured: the Machine Hall.

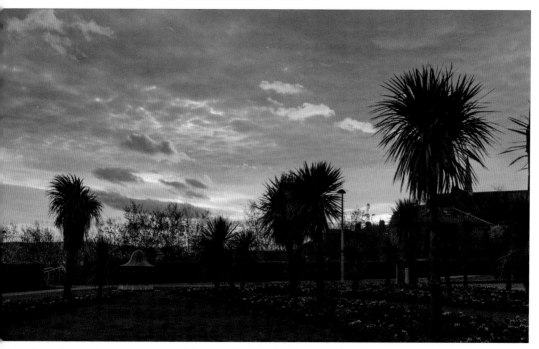

Seen from the garden across the road from Airlie Place, a fiery evening sky silhouettes the palm trees **61** (or trees that look like palm trees!).

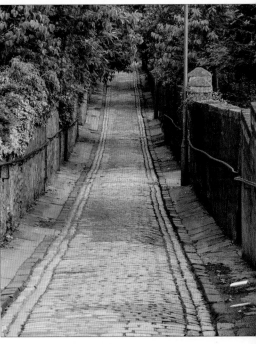

62 Left: at the entrance to the same garden, a trio of strange creatures can be seen.
Right: further along Perth Road from Airlie Place, the cobblestones of Strawberry Bank . . .

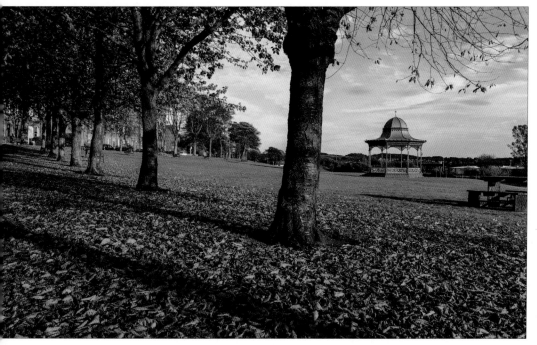

. . . lead down to Magdalen Green, where a carpet of autumn leaves catches the late afternoon sun. **63**
The bandstand, built in 1890, is also warmed by the sunlight.

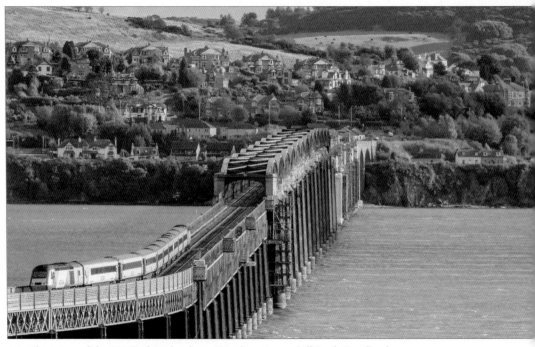

64 This view of the Tay Rail Bridge from Windsor Street (off Perth Road) telescopes its two mile/three km. length and gives an illuminating impression of its construction.

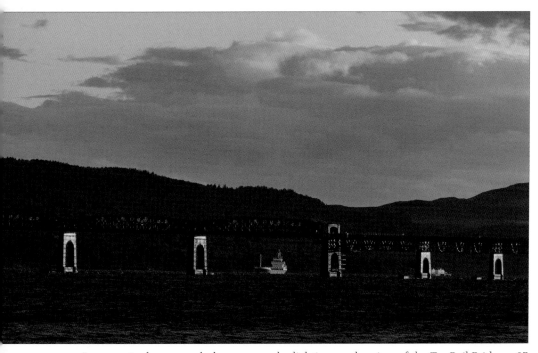

Low sun in the west splashes spectacular lighting on the piers of the Tay Rail Bridge. **65**

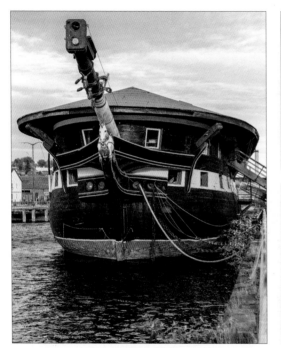
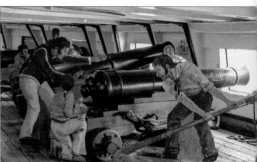
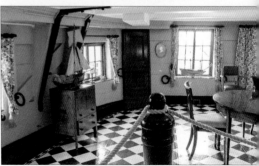

66 Three scenes from HM Frigate *Unicorn*, which was launched in 1824. She is one of the six oldest ships in the world, berthed in Dundee's Victoria Dock and open to the public.

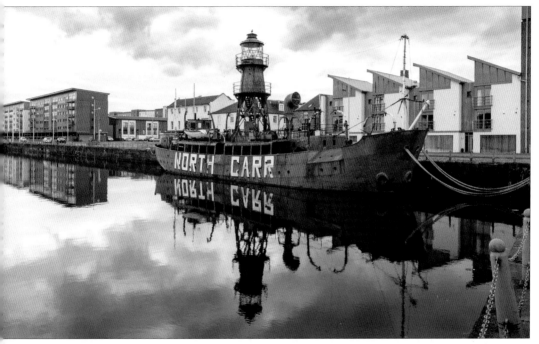

The retired North Carr Lightship also spends its retirement in Victoria Dock. Dating from 1933, **67**
the 31m/101ft vessel is the last of its kind and now awaits restoration.

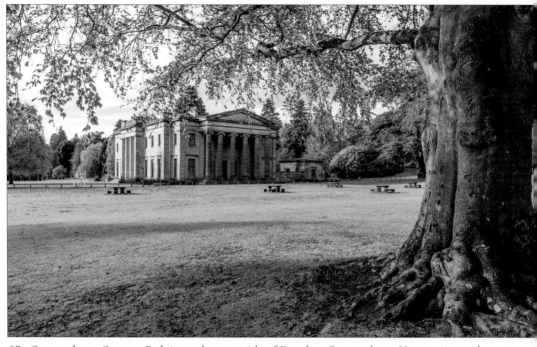

68 Camperdown Country Park is on the west side of Dundee. Camperdown House, pictured, was built by the Duncan family in 1828 and named after the battle of Camperdown – see p.44.

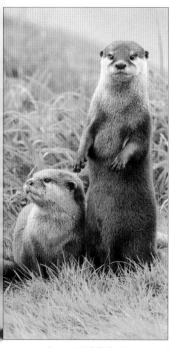
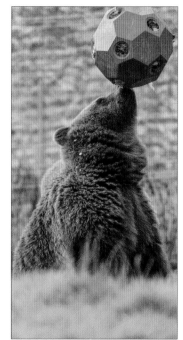
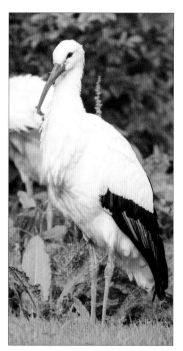

Camperdown Wildlife Centre is located within Camperdown Country Park and has a wide variety of **69** animals, including left: European brown bear; centre: European otters; right: white storks.

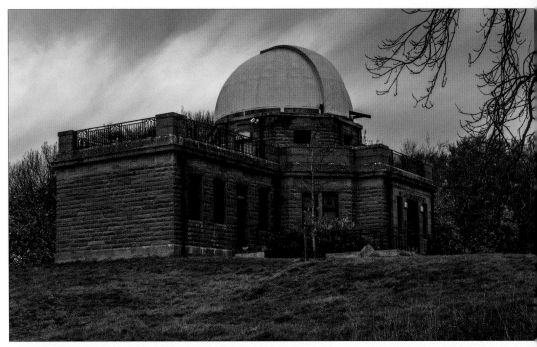

70 Situated atop this hill in Balgay Park, Mills Observatory was the first purpose-built public astronomical observatory in the UK. Built in 1935, its dome houses a Victorian refracting telescope.

Balgay Hill is also home to one the city's cemeteries, a place of leafy tranquillity; a place ideal for remembrance and reflection.

72 Dundee is well endowed with many fine parks and gardens, one of which is Baxter Park on Arbroath Road, named after the Baxter family, flax mill owners, who gifted the park to the city in 1863.

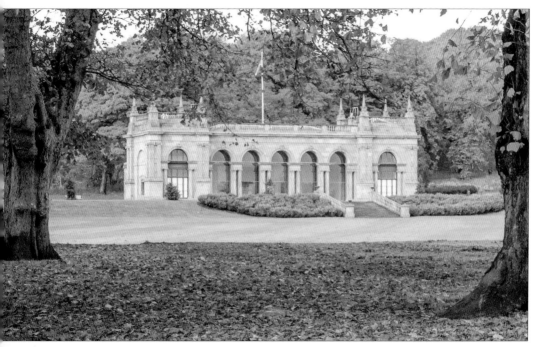

The historic, glass-fronted Italianate pavilion on the right adds classical grandeur to the park. It was designed by George Henry Stokes.

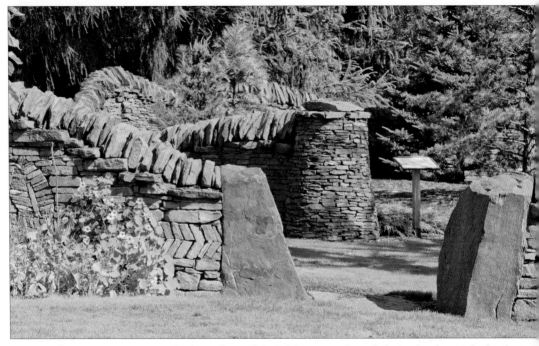

74 Dundee University Botanic Garden is located in 9.5 hectares of south-facing land near the banks of the River Tay. These attractive walls are a feature that was added from 2006 to 2008.

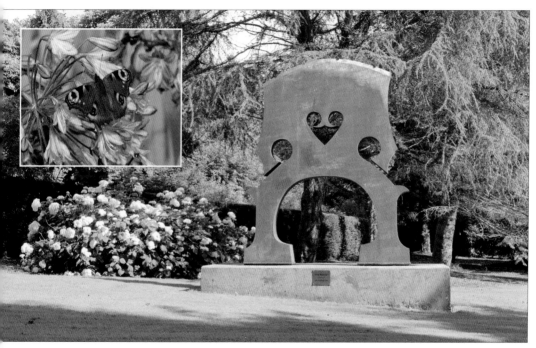

The Garden is also home to this impressive sculpture by Ron Martin called 'The Bridge'. **75**
Inset: Peacock butterfly on blue agapanthus flowers.

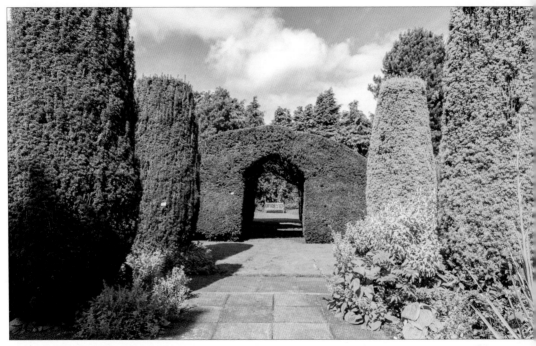

76 Wonderful topiary at Dundee University Botanic Garden, both in the shaping of the trees in the foreground and in the massive hedge tunnel beyond.

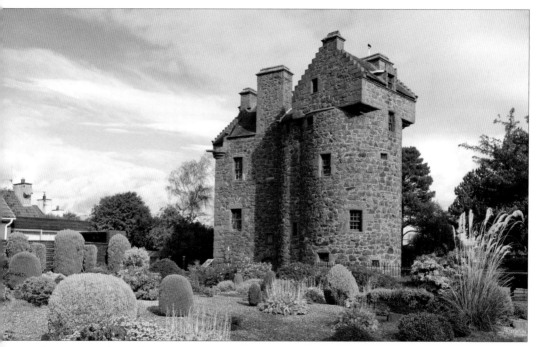

Claypotts Castle, in the West Ferry area of Dundee, is an outstanding example of 16th-century Scottish architecture which is both intact and little altered. It was built 1569-1588 by John Strachan.

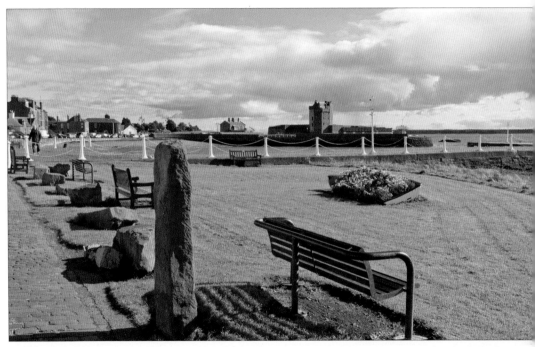

78 Broughty Ferry is a small port and residential suburb just east of Dundee. It used to be linked by ferry to Tayport in Fife and from 1854 operated the first 'roll on-roll off' train ferry.

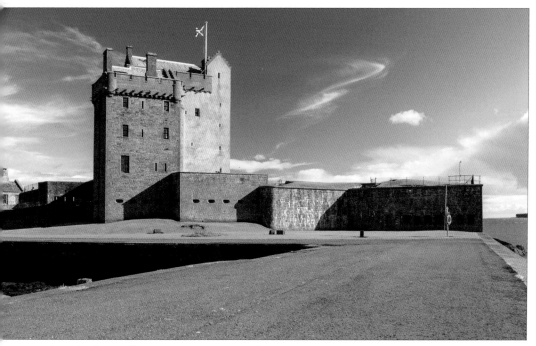

Built in the late 15th century, Broughty Castle has been adapted through the years to meet the
nation's changing defence needs until 1932. Today it houses a museum run by Dundee City Council.

STRANGERS
MUST RING
THIS BELL

Published 2019 by Lyrical Scotland, an imprint of Lomond Books Ltd, Broxburn, EH52 5NF
www.lyricalscotland.com www.lomondbooks.com

Originated by Ness Publishing, 47 Academy Street, Elgin, Moray, IV30 1LR

Printed in China

All photographs © Colin Nutt except p.54 courtesy of Dundee and Angus College;
p.60 © Dundee Heritage Trust, Verdant Works; thanks to Dundee Art Galleries and Museums
(Dundee City Council) for their co-operation with the picture on p.47.

Text © Colin Nutt
ISBN 978-1-78818-073-3

Front cover: V&A Dundee; p.1: Dundee City Crest; p.4: meerkat at Camperdown Wildlife Centre;
this page: an 'instruction' at Dundee University; back cover: Tay Rail Bridge